Chihuly

PUTTI

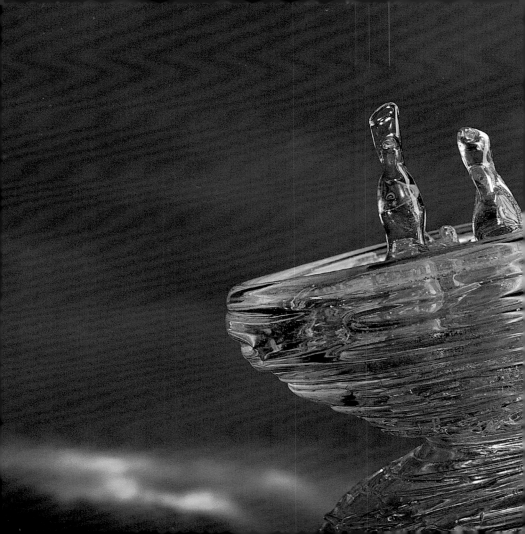

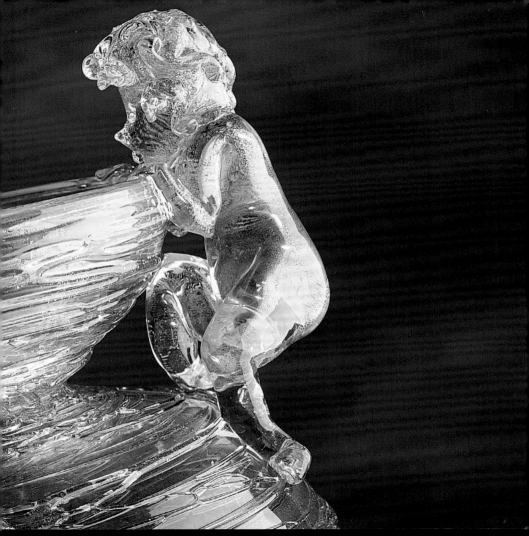

A TOUCH OF MISCHIEF

DALE CHIHULY HAS ALWAYS CREDITED THE TEAMS OF GLASSBLOWERS he assembles for his success in making glass a vehicle for contemporary expression. Recognizing the need for American artists to master historical techniques, he also has always been a strong advocate for learning Italian practices, making his collaboration with the Italian master Pino Signoretto (b. 1944) critical not only for his own development but for that of American artists in general. Ranging over almost two decades, the *Putti* series, which was the result of an alliance between Signoretto and Chihuly, expanded in new directions Chihuly's ongoing investigation of the monumental blown-glass vessel. In this series, Chihuly combined the vessel with solid hot-glass figurative and representational sculpture, thereby creating forms that acknowledge earlier decorative arts while solidly positioning themselves within the realm of contemporary large-scale sculpture.

The *Putti* series evolved from an invitation that Chihuly received in 1989 to conduct a demonstration at Pilchuck Glass School with Signoretto, who was teaching a summer course for the first time. By that point, Signoretto was head of his own factory on the island of Murano, Italy, having achieved "maestro" status in its glass community as early as 1960. Trained by Alfredo Barbini and Archimede Seguso, who in the 1930s developed the technique of *massiccio*—

Preceding page:
May Green
Putti Venetian (detail)

1991, 22 x 13 x 13"

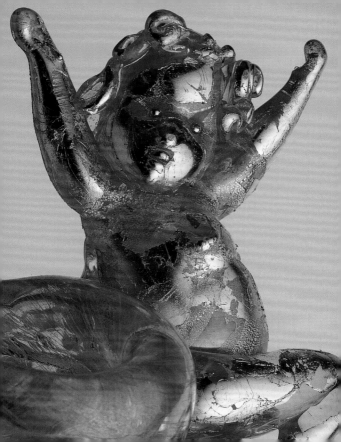

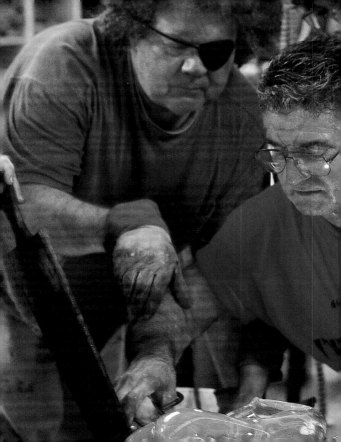

the creation of solid sculpture by modeling freehand a mass of molten glass—Signoretto is one of the few masters to practice this uniquely Italian method. Signoretto's skills have been widely recognized; the artists with whom he has collaborated include Salvador Dali, Arnoldo Pomodoro, Giacomo Manzù, Timo Sarpaneva, Jeff Koons, and Kiki Smith.

In response to the invitation to work with Signoretto, Chihuly developed the idea of a series using the *putto* (Italian for "cherub") form. Today, he no longer recalls his initial rationale, and notes: "Normally, I don't like the looks of figures in glass." Some say he was enthralled with the sound of the word "*putti.*" Others attribute it to the influence of the painter and sculptor Italo Scanga, Chihuly's very close friend who immersed him in Italian culture. At the time, Chihuly associated *putti* with the wood or plaster forms that lent lightheartedness to Renaissance and Baroque art, even in churches. It has also been suggested that the form originally was intended as a self-portrait. Chihuly himself has commented that he had felt these chubby little nude boys could introduce a mischievous element into his work.

The start of the *Putti* series was notable since it was the first time that Chihuly, Signoretto, and Lino Tagliapietra

Chihuly, J. P. Canlis, and Pino Signoretto

The Boathouse hotshop
Seattle, Washington, 1998

ever worked together. Chihuly, who invited Tagliapietra to join the blow at Pilchuck, is particularly proud of the role he played in getting these two Italian glass masters to collaborate, since, he said, this was "something that simply would never happen in Murano." Interestingly, the first vessel of the *Putti* series did not contain *putti*, but only animals, which Signoretto loved to make; by the end of that blow, however, a vase with *putti* was produced. A second session with the two Italian masters was held at Chihuly's Boathouse studio shortly thereafter.

In addition to Signoretto, several members of Team Chihuly have played key roles in the *Putti* series. Richard Royal was lead gaffer for many of the vessels. Signoretto fabricated many but not all of the figures and animals for the series. Martin Blank, who worked with Signoretto in 1989 when the first *Putti Venetians* were created, fabricated the figures in the early 1990s when Signoretto was not available. By the mid-1990s, Paul DeSomma, who also had learned the technique from Signoretto, had become key in their fabrication.

The *Putti* customarily employed large teams, ranging upwards of ten artists. At times, Chihuly and Signoretto

Payne's Gray
Venetian with Putti

1989, 22 x 15 x 15"

8

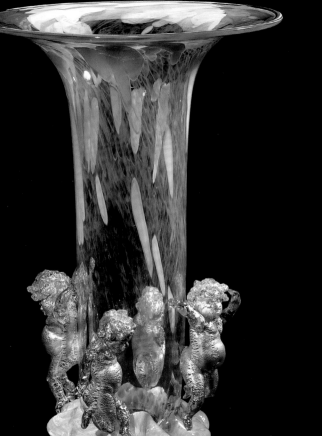

I love the Pottie !

would select the sculptural forms from books. More frequently, Chihuly's drawings would serve as the model, since Signoretto was particularly adept in sculpting directly from objects or drawings. Often, communication was more improvisational, simply by gesture, with Chihuly never demanding verisimilitude in the execution. Beginning in 1994, Amber Hauch, who started working with Signoretto, joined the sessions to expedite the creative process.

Like much of Chihuly's work, the *Putti* evolved over a period of time and in several phases, some lasting several years. The earliest phase, the gold-leafed *Putti Venetians*, was begun approximately a year after the *Venetian* series. In these works, *putti* perch like gilded mounts on the bases, handles, and mouths of the *Venetian* forms. On the *Putti Ikebana* of the early 1990s, their placement became more prominent: they hang precariously on the flower petals or on the stems.

From 1993–94 through the end of the decade, the *Putti* became more central to the compositions, sitting atop large blown-glass vessel forms. They appear engaged in playful activities with birds, sea creatures, other animals, and plants. They are assembled on top of a stopper that is

fitted into the vessel and as a result resemble perfume bottles. These sculptures sometimes measure up to four feet in height. In discussions of this stage, the sculptures are usually divided into three categories—*Putti + Birds, Sealife*, and *Putti + Sealife*—since not all works in the series actually include *putti*.

When Chihuly revisited the *Putti + Sealife* in 2000, another change in the *Putti* series occurred: the sea creatures are fused in random patterns over the entire surface of the vessel, some of which are *Cylinder* forms. Although only a few of these forms were created, they are interesting because of their resemblance to Lalique vases of the 1910s and 1920s. While the *Venetian Ikebana*, executed in 2001 and 2002, return to the perfume-bottle format with some modifications, the most recent *Black Sealife* pieces, many of which tower upwards of five feet, are groundbreaking. Completed in 2006 while Signoretto was in Tacoma, Washington, these forms are the most monumental of the entire series. In many instances, the sculptures overshadow the vases and transform them into bases.

Interestingly, the *putti* and sea-life figures do not appear often in Chihuly's installations. In fact, they are

Putti with Goldfish
and Bamboo atop
Gilt Sapphire Vessel (detail)

2002, 45 x 18 x 18"

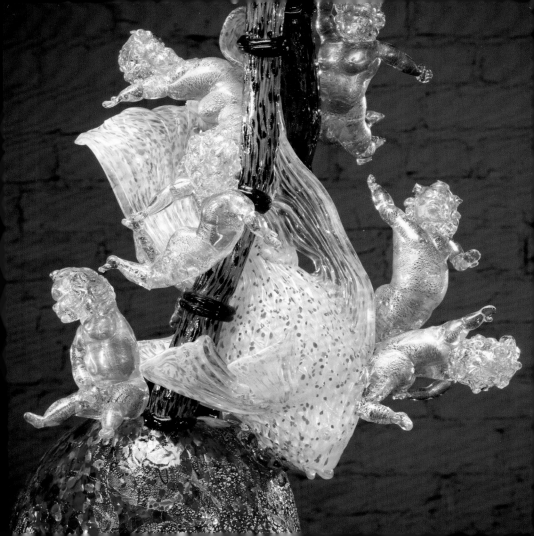

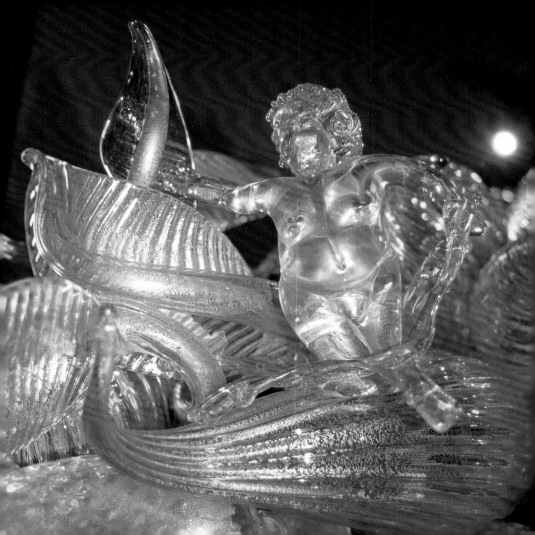

found only sporadically on the *Chandeliers* and *Towers*. One of the most spectacular environments that contain these sculptures is the *Laguna Murano Chandelier*, begun in 1996 in Signoretto's Murano studio. Mermaids, sharks, scallops, and other sea creatures are fused onto glass pods, which are then surrounded by "kelp"—the swirling, linear, blown-glass elements that constitute the *Tower* and *Chandelier* forms of this complex five-part composition.

Davira S. Taragin

Former Director of Exhibitions and Programs,

Racine Art Museum;

former Curator, The Detroit Institute of Arts,

Toledo Museum of Art

Copper and Gilded Putti
Sealife Chandelier (detail)

2001, 9 x 5 x 5'

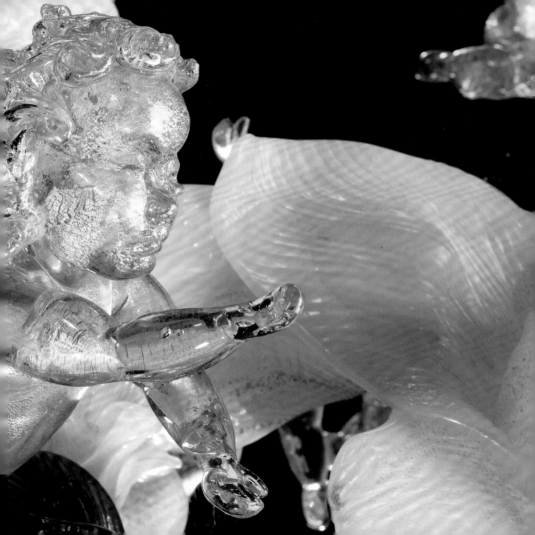

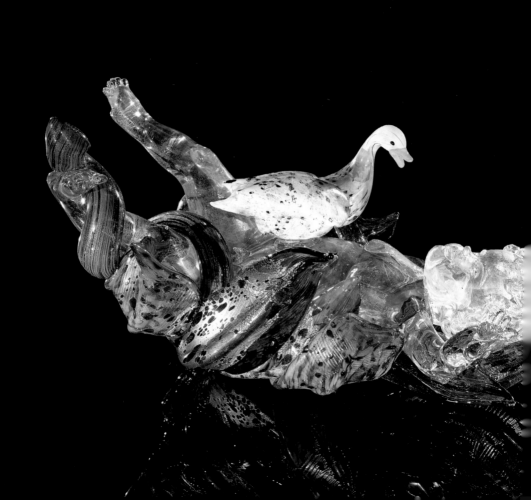

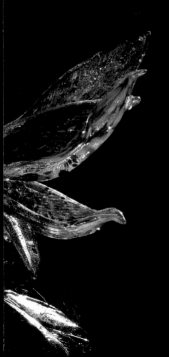

Gilded Putto with
Leaves and Swan

1991, 11 x 24 x 12"

Putti on
Blue Vessel

The Boathouse
Seattle, Washington
1991, 33 x 13 x 12"

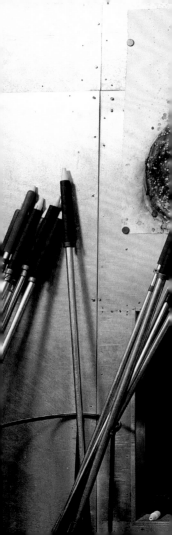

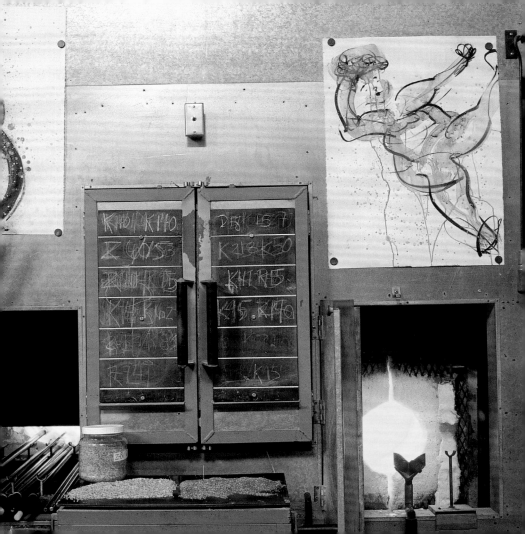

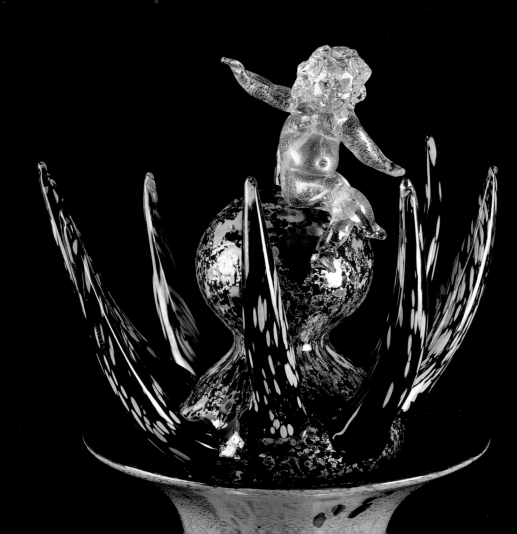

Gold over
Forest Green
Putti Ikebana

1991, 36 x 16 x 16"

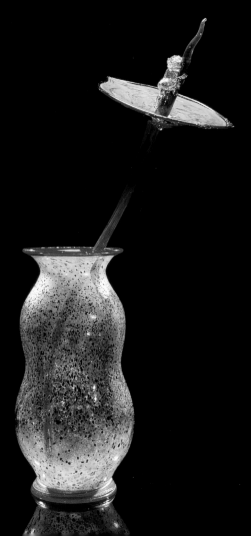

**May Green Ikebana
with Putto Stem**

1991, 50 x 24 x 11"

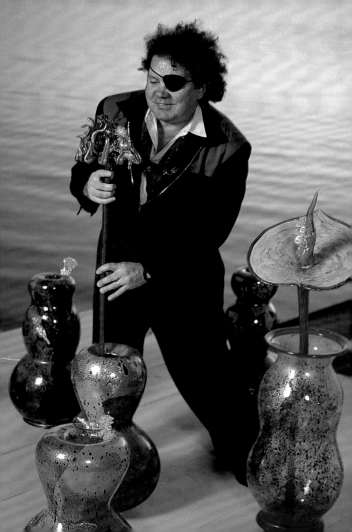

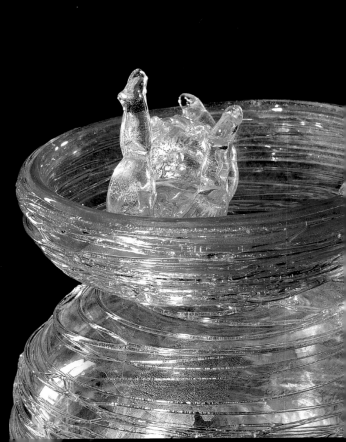

**Cerulean Blue
and Gold
Putti Venetian**

1991, 14 x 10 x 9"

Putti Drawing

1992, 30 x 22"

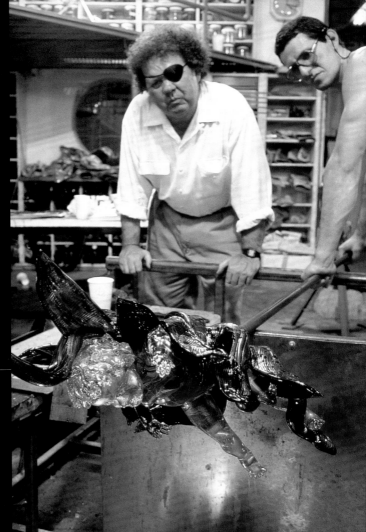

Chihuly and Paul DeSomma

The Boathouse hotshop
Seattle, Washington, 1991

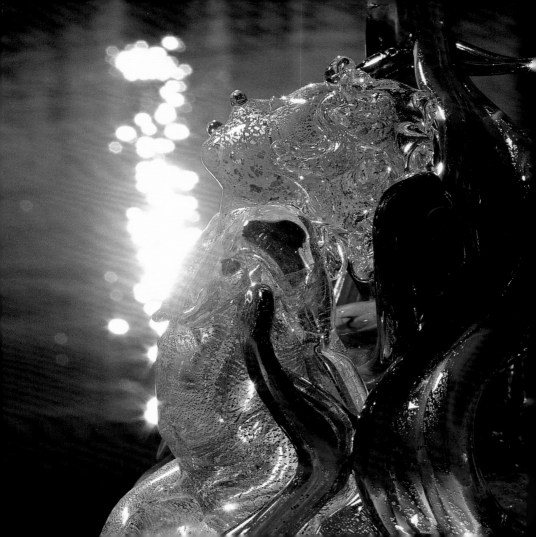

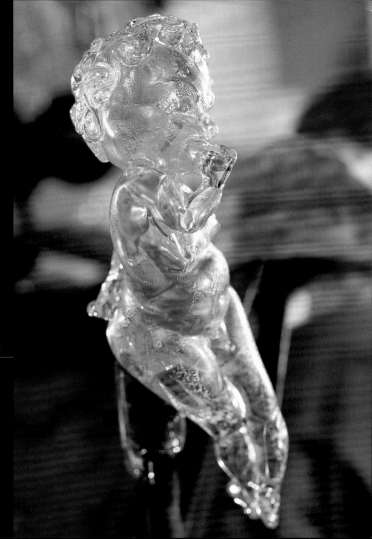

Putto (detail)

The Boathouse
Seattle, Washington, 1991

Putto in process

The Boathouse hotshop
Seattle, Washington, 1991

Putti Ikebana

The Boathouse
Seattle, Washington, 1991

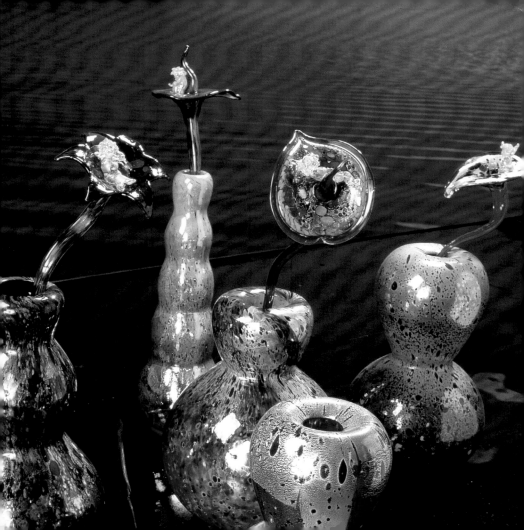

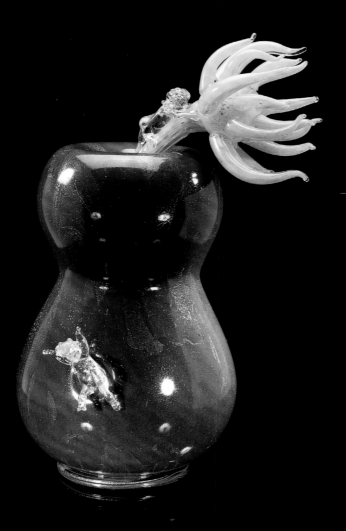

**Plum Putti
Ikebana with
Single Stem**

1991, 27 x 16 x 13"

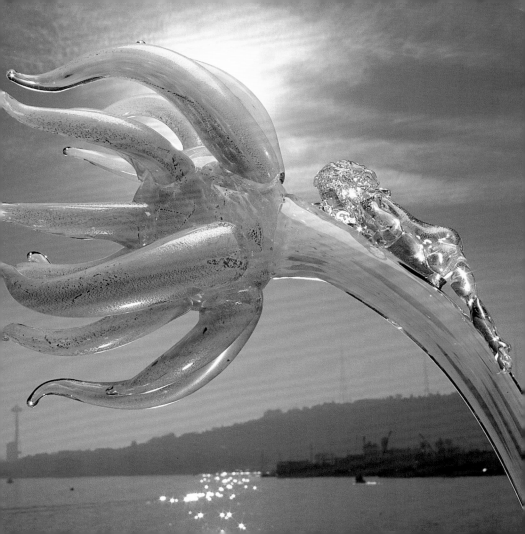

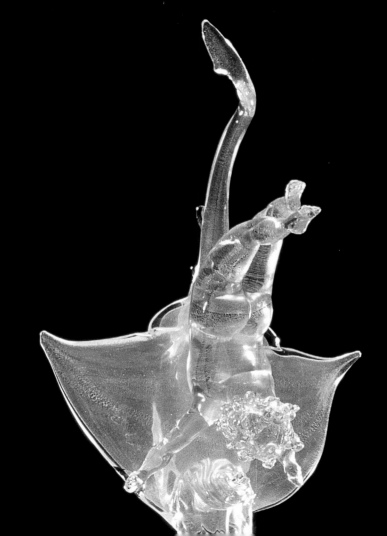

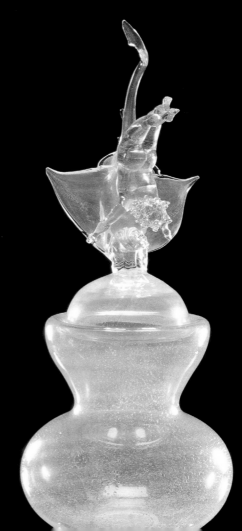

**Putto Swimming
with Stingray on
Chartreuse Vessel**

2000, 31 x 12 x 12"

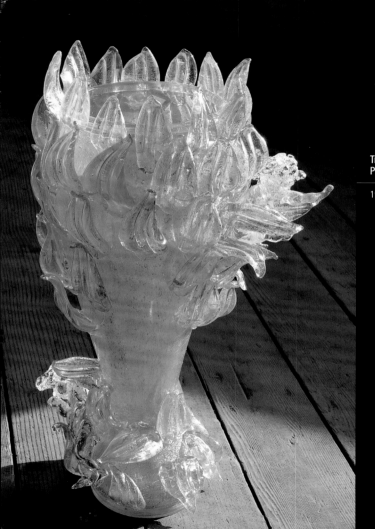

Translucent Viridian
Putti Venetian

1993, 23 x 12 x 9"

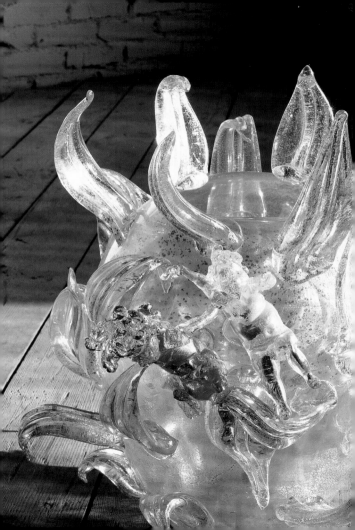

**Erbium Chandelier with
Gilded Putto (detail)**

1993, 3 x 4½ x 4½'

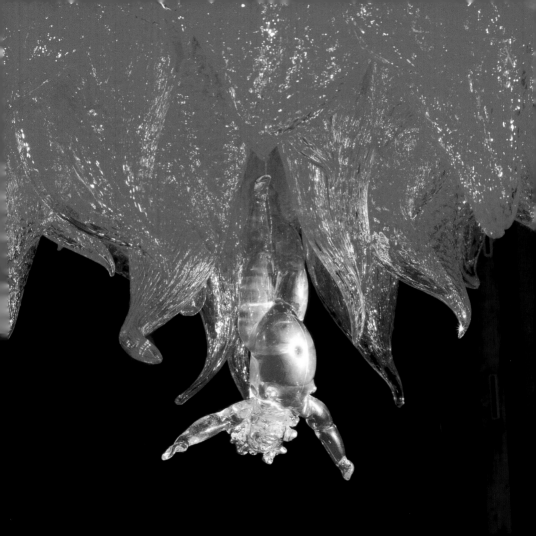

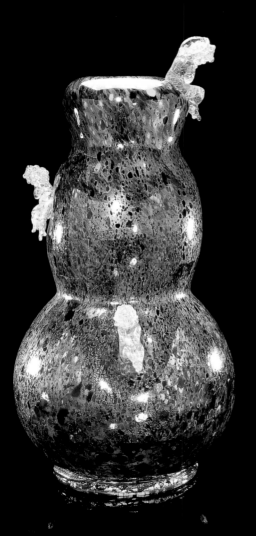

Dappled
Midnight Blue
Putti Venetian

1990, 27 x 13 x 13"

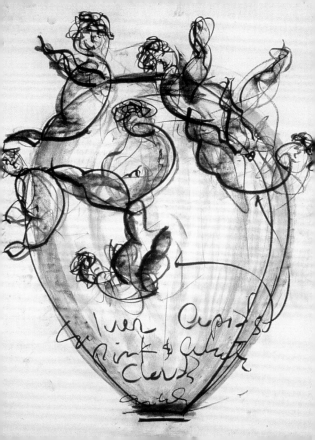

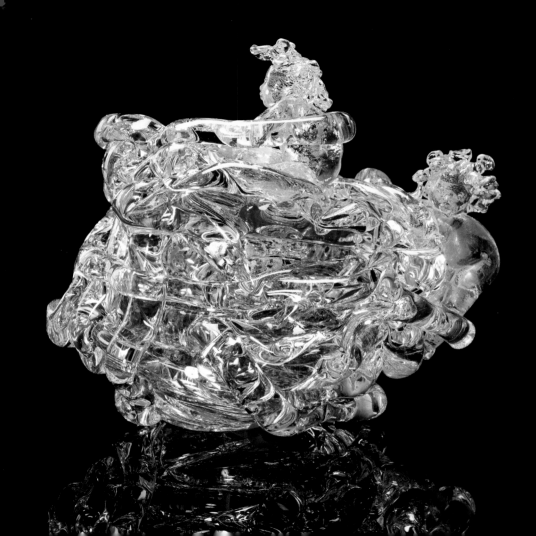

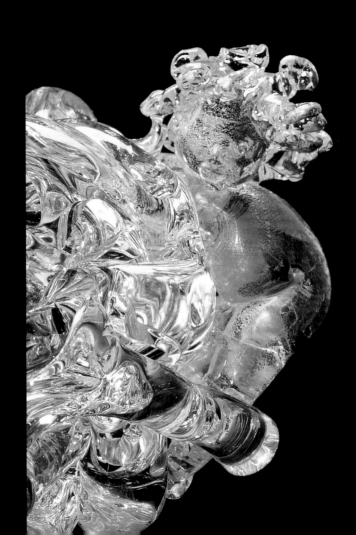

Spotted Blue
and Green
Transparent Putti

1994, 9 x 10 x 8"

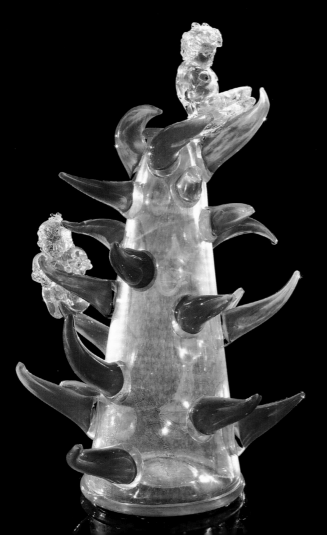

Gold Over Clear
Raspberry Putti
Venetian with Prunts

1994, 26 x 15 x 15"

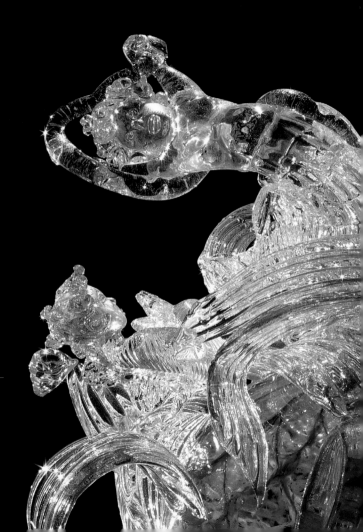

Translucent Blue Putti
Venetian with Gilt Leaves
and Dragons (detail)

1994, 17 x 16 x 14"

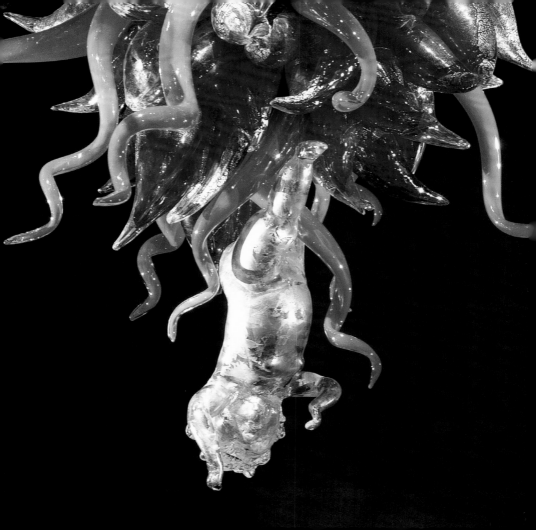

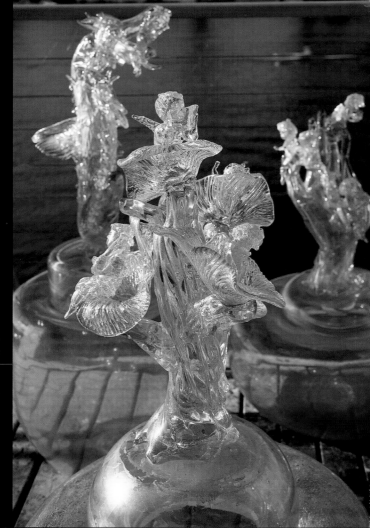

Red Horn and
Silver Blue Chandelier
with Putto (detail)

2004, 3 x 3 x 3'

Putti on
Boathouse Deck

The Boathouse
Seattle, Washington, 1996

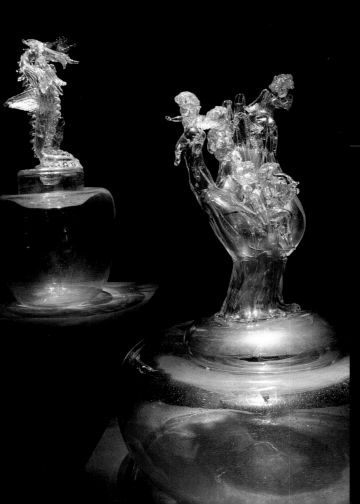

Putti Stoppers

Portland Art Museum
Portland, Oregon, 1997

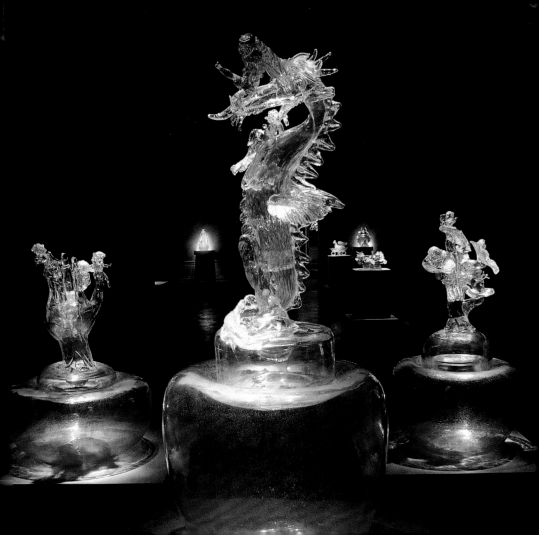

early
10-7-97

Putti picking
an apple
with part of
a tree.

having
a good
time in
the Fall

Don't
forget
legs

Fax sketch

1997

Golden Sea Putto with
Carp Reclining on
Scarlet-Edged Pillow

1997, 7 x 15 x 15"

003

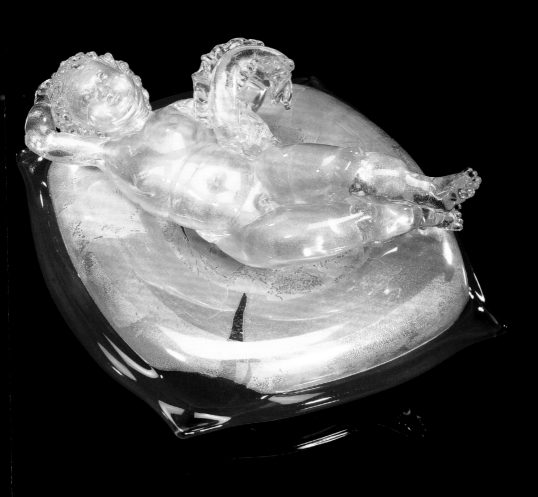

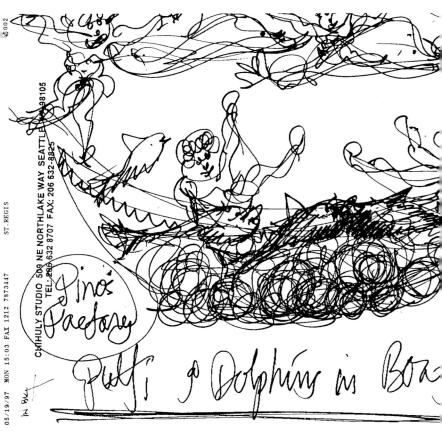

Puffi, a Dolphins in Bo—

Fax sketch

1997

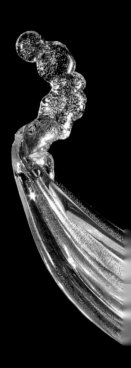

**Putto with Gondola
and Sea Curls**

1997, 10 x 13 x 7"

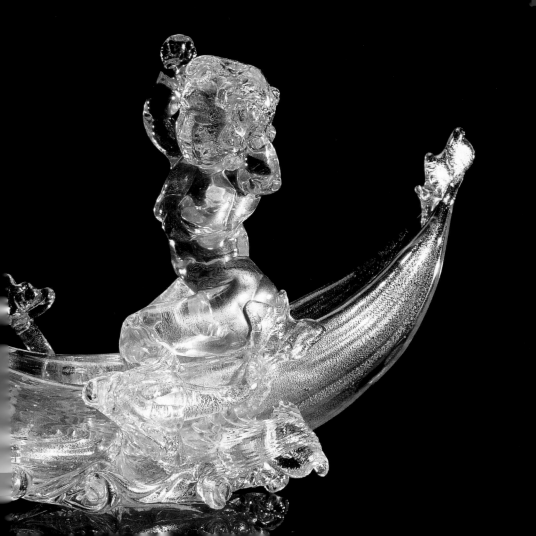

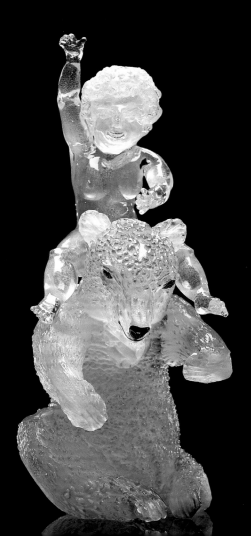

**Putto con Orso Bianco
(Putto with White Bear)**

1997, 22 x 9 x 12"

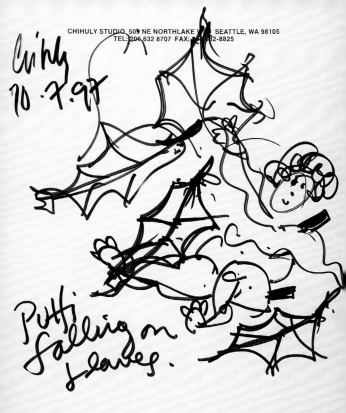

Chihy
10·7·97

Putti
falling on
leaves.

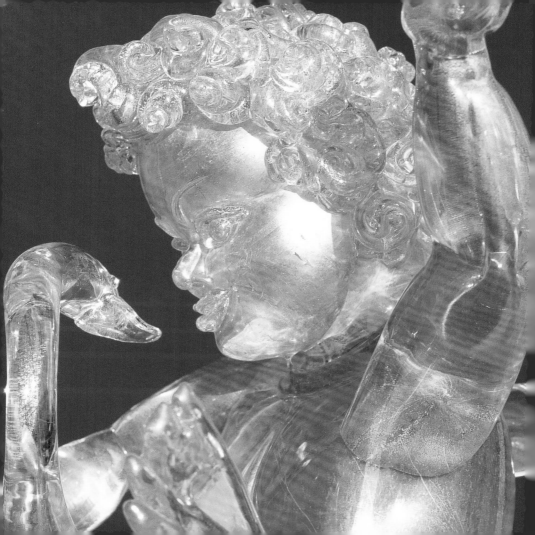

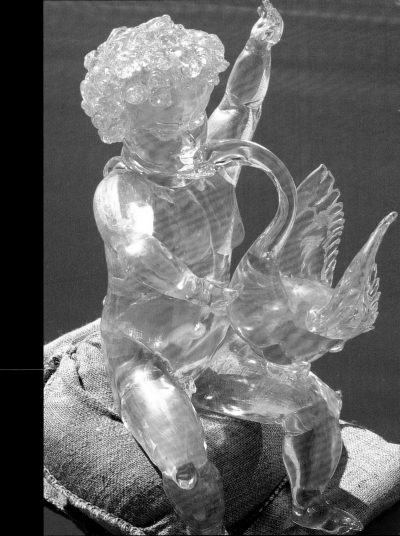

Putto con Cigno
(Putto with Swan)

1997, 12 x 12 x 23"

Patricia Davidson, Pino
Signoretto, Chihuly,
and Paul DeSomma

The Boathouse hotshop
Seattle, Washington, 1998

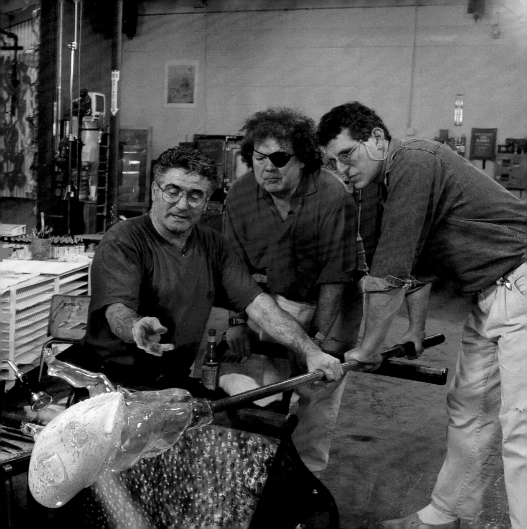

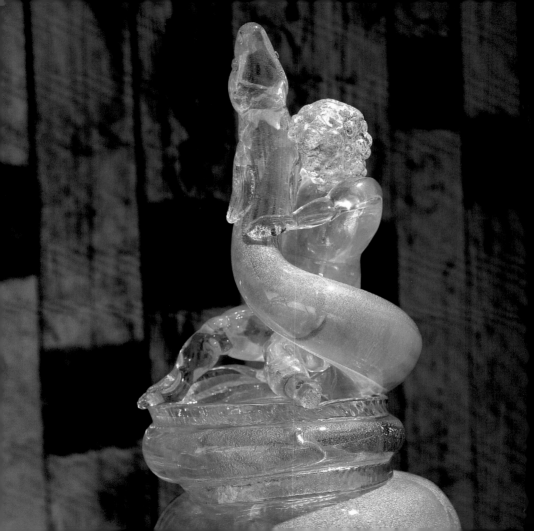

**Putto Charming
Sea Snake (detail)**

1998, 31 x 14 x 14"

Putti Drawing

1989, 30 x 22"

**Putto con Pesce Rosso
(Putto with Goldfish) (detail)**

1998, 27 x 13 x 14"

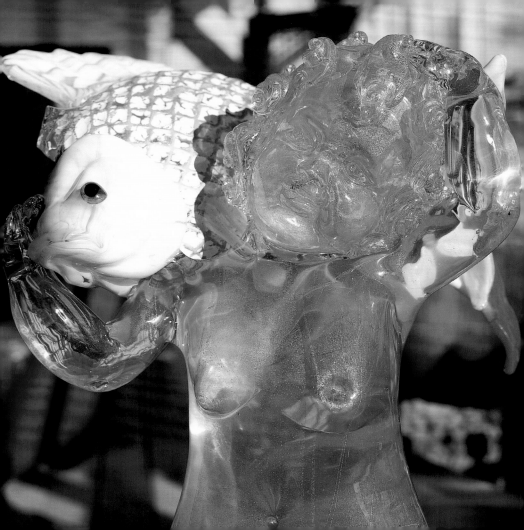

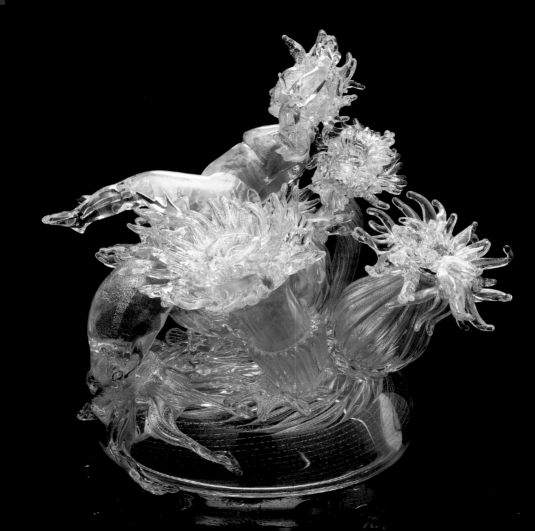

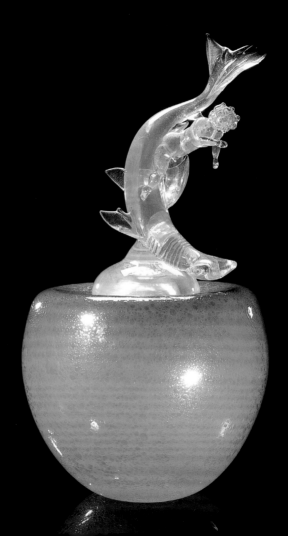

**Putto in
Sealife Garden**

1998, 9 x 9 x 9"

**Putto Riding
Hammerhead
atop Marine
Green Vessel**

1998, 36 x 18 x 18"

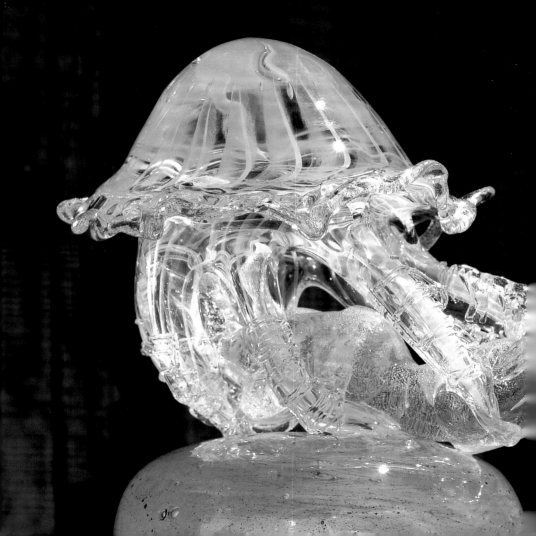

Putto with Man-of-War (detail)

1998, 25 x 12 x 12"

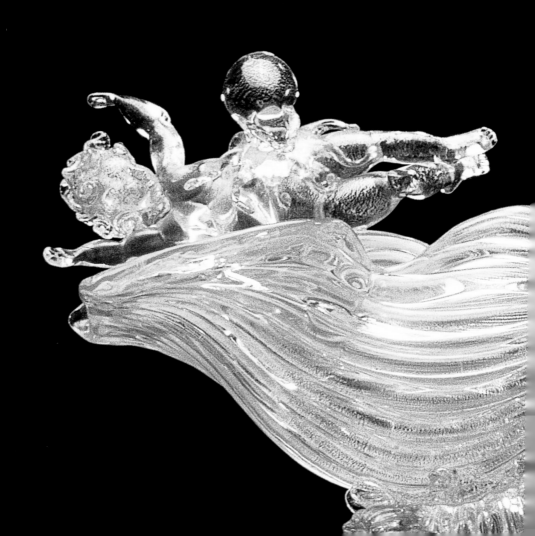

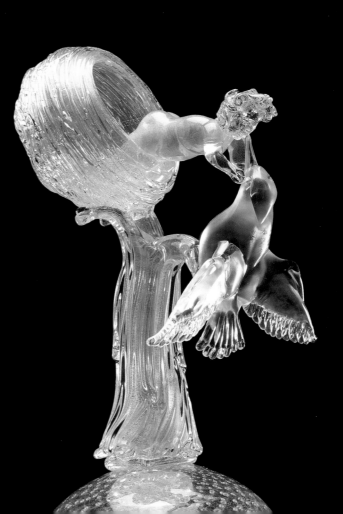

Putto with Octopus and Shell on Pink Base (detail)

1999, 31 x 17 x 17"

Putto in Nest Kissing Opalescent Hummingbird on Orange Vessel (detail)

1999, 31 x 18 x 18"

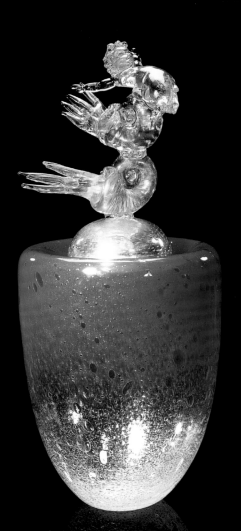

**Putto Basking
with Nautilus
on Ice Blue Base**

1999, 29 x 12 x 12"

Putti Venetian
Drawing

2001, 30 x 22"

Charlie Lowry,
Pino Signoretto,
Paul DeSomma,
and Daryl Smith

The Boathouse hotshop
Seattle, Washington, 2001

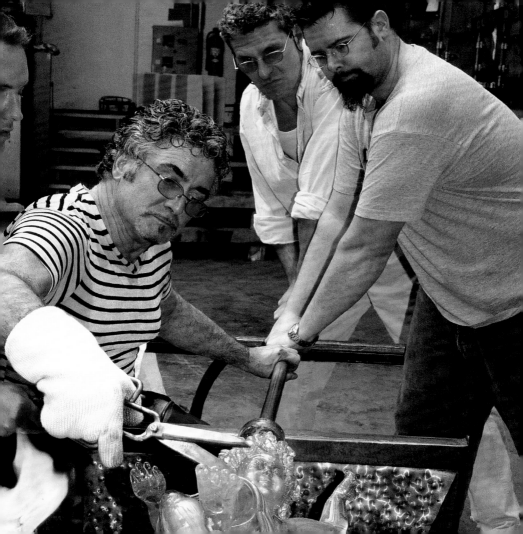

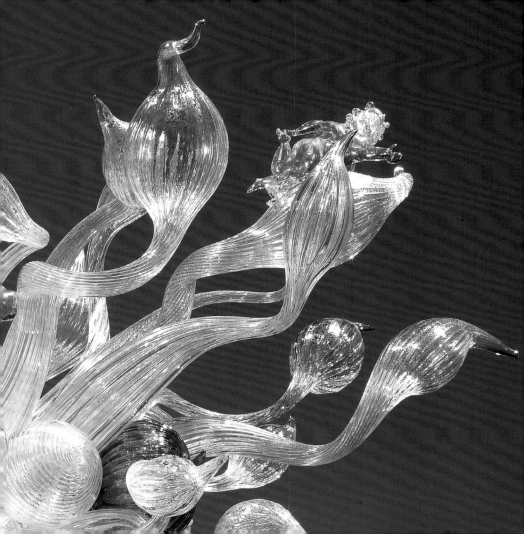

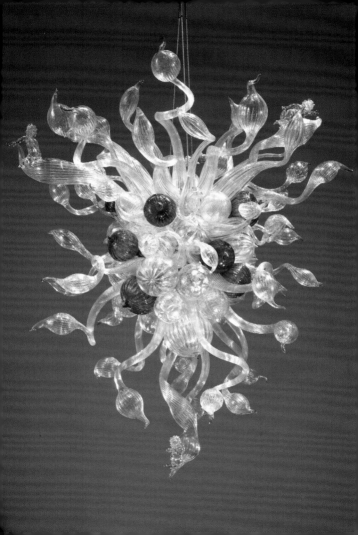

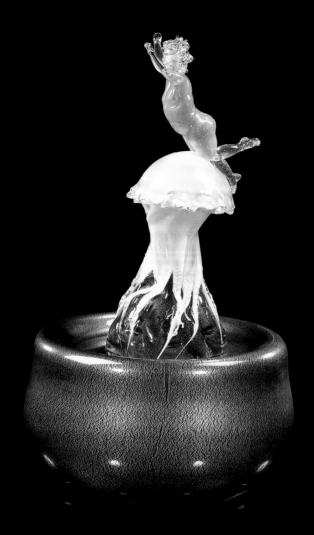

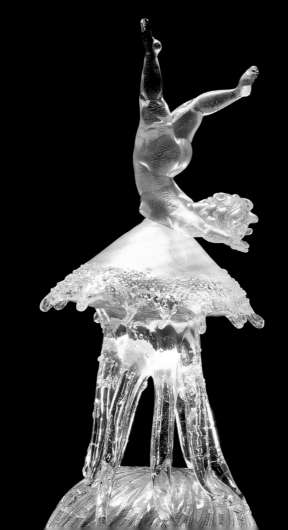

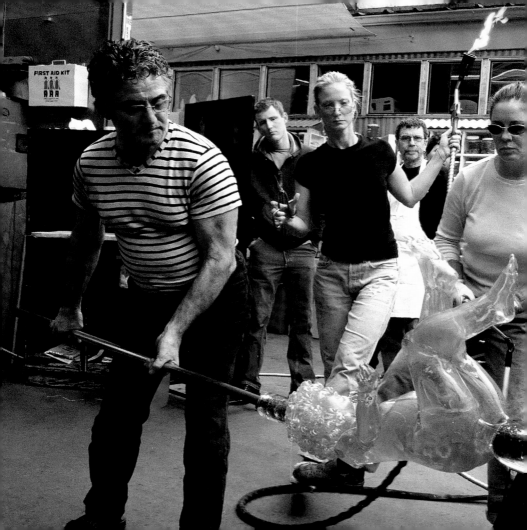

Pino Signoretto, Amber Hauch, and Patricia Davidson

The Boathouse hotshop
Seattle, Washington, 2001

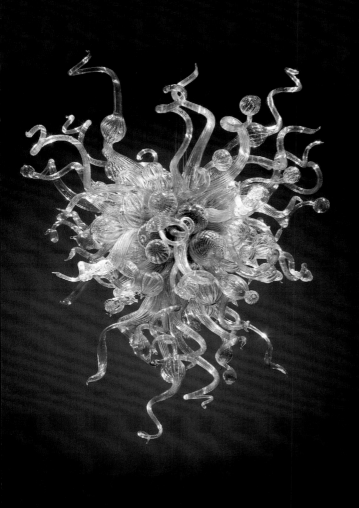

Citron Green
Chandelier

2001, 4½ x 4½

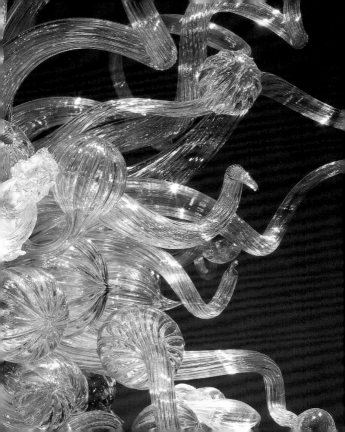

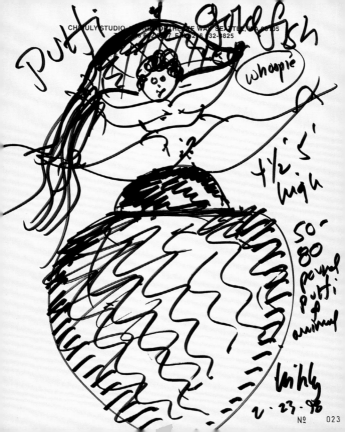

**Putto and Turtle
atop Gilded
Bronze Vessel**

2001, 35 x 14 x 14"

Viridian and Yellow
Putti Venetian Ikebana on
Green Vessel (detail)

2002, 40 x 21 x 18"

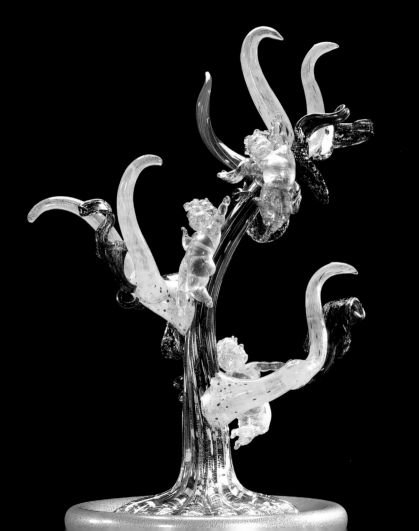

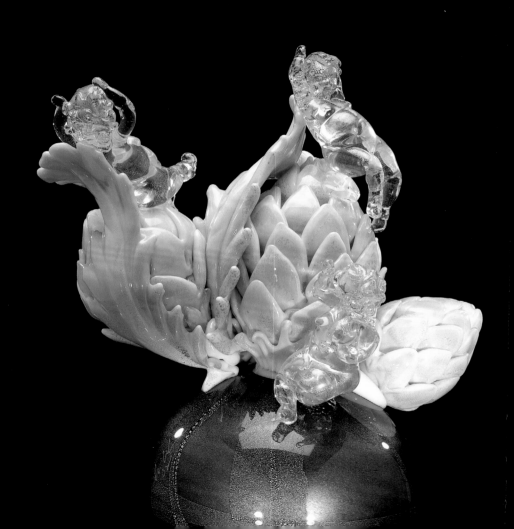

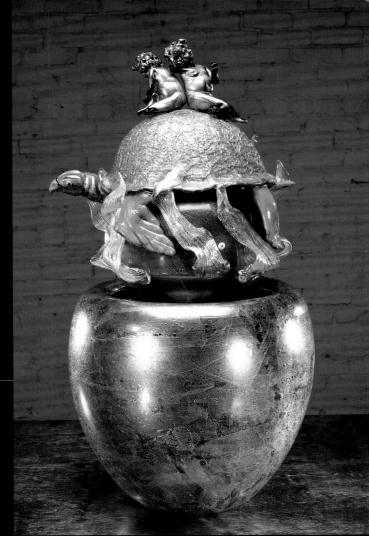

Artichokes with
Reclining Putti

2002, 20 x 18 x 15"

Black Putti Riding
Sea Turtle on
Golden Plum Vessel

2002, 29 x 15 x 15"

Ivory Starfish Holding Putto
atop Bronze Vessel (detail)

2001, 27 x 17 x 17"

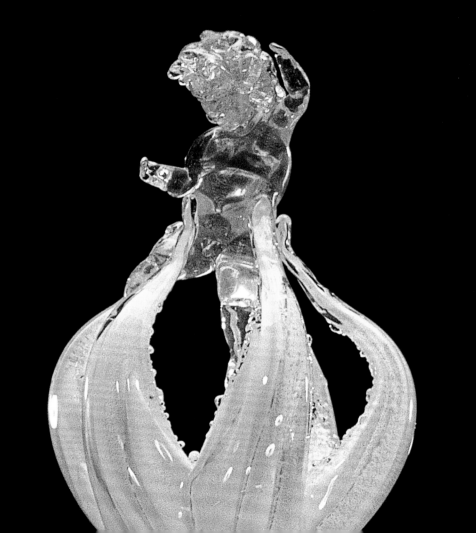

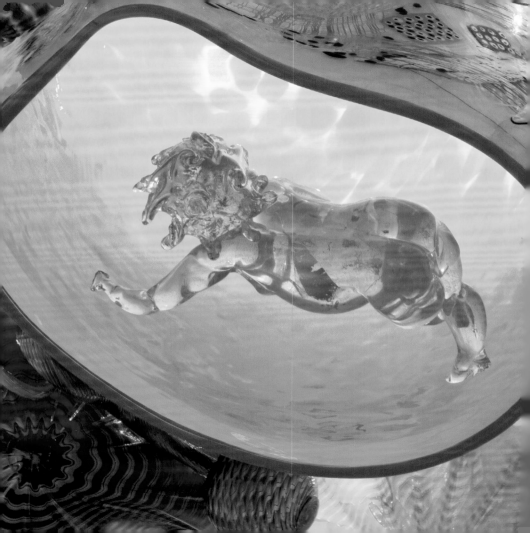

Persian Ceiling (detail)

de Young Museum
San Francisco, California, 2008

Following page:
Gilt Tangerine Putti
Venetian with Handles
and Ribbons (detail)

1994, 19 x 13 x 13"

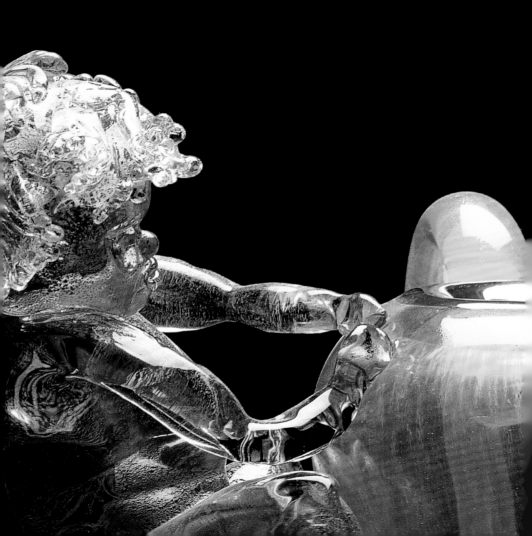

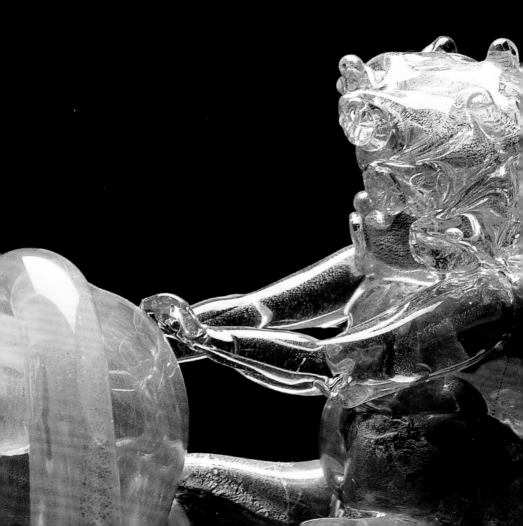

CHRONOLOGY

1941 Born September 20 in Tacoma, Washington, to George Chihuly and Viola Magnuson Chihuly.

1957 Older brother and only sibling, George, is killed in a Naval Air Force training accident in Pensacola, Florida.

1958 His father suffers a fatal heart attack at age 51. His mother goes to work to support Dale and herself.

1959 Graduates from high school in Tacoma. Enrolls in the College of Puget Sound (now the University of Puget Sound) in his hometown. Transfers to the University of Washington in Seattle to study interior design and architecture.

1961 Joins Delta Kappa Epsilon fraternity and becomes rush chairman. Learns to melt and fuse glass.

1962 Disillusioned with his studies, he leaves school and travels to Florence to study art. Discouraged by not being able to speak Italian, he leaves and travels to the Middle East.

1963 Works on a kibbutz in the Negev Desert. Returns to the University of Washington in the College of Arts and Sciences and studies under Hope Foote and Warren Hill. In a weaving class with Doris Brockway, he incorporates glass shards into woven tapestries.

1964 Returns to Europe, visits Leningrad, and makes the first of many trips to Ireland.

1965 Receives B.A. in Interior Design from the University of Washington. Experimenting on his own in his basement studio, Chihuly blows his first glass bubble by melting stained glass and using a metal pipe.

1966	Works as a commercial fisherman in Alaska to earn money for graduate school. Enters the University of Wisconsin at Madison, where he studies glassblowing under Harvey Littleton.
1967	Receives M.S. in Sculpture from the University of Wisconsin. Enrolls at the Rhode Island School of Design (RISD) in Providence, where he begins his exploration of environmental works using neon, argon, and blown glass. Awarded a Louis Comfort Tiffany Foundation Grant for work in glass. Italo Scanga, then on the faculty at Pennsylvania State University's Art Department, lectures at RISD, and the two begin a lifelong friendship.
1968	Receives M.F.A. in Ceramics from RISD. Awarded a Fulbright Fellowship, which enables him to travel and work in Europe. Becomes the first American glassblower to work in the Venini factory on the island of Murano. Returns to the United States and spends four consecutive summers teaching at Haystack Mountain School of Crafts in Deer Isle, Maine.
1969	Travels again throughout Europe and meets glass masters Erwin Eisch in Germany and Jaroslava Brychtová and Stanislav Libenský in Czechoslovakia. Returning to the United States, Chihuly establishes the glass program at RISD, where he teaches for the next fifteen years.
1970	Meets James Carpenter, a student in the RISD Illustration Department, and they begin a four-year collaboration.
1971	On the site of a tree farm owned by Seattle art patrons Anne Gould Hauberg and John Hauberg, the Pilchuck Glass School

experiment is started. Chihuly's first environmental installation at Pilchuck is created that summer. He resumes teaching at RISD and creates *20,000 Pounds of Ice and Neon*, *Glass Forest #1*, and *Glass Forest #2* with James Carpenter, installations that pre-figure later environmental works by Chihuly.

1972 Continues to collaborate with Carpenter on large-scale architectural projects. They create *Rondel Door* and *Cast Glass Door* at Pilchuck. Back in Providence, they create *Dry Ice, Bent Glass and Neon*, a conceptual breakthrough.

1974 Supported by a National Endowment for the Arts grant at Pilchuck, James Carpenter, a group of students, and he develop a technique for picking up glass thread drawings. In December at RISD, he completes his last collaborative project with Carpenter, *Corning Wall*.

1975 At RISD, begins series of *Navajo Blanket Cylinders*. Kate Elliott and, later, Flora Mace fabricate the complex thread drawings. He receives the first of two National Endowment for the Arts Individual Artist grants. Artist-in-residence with Seaver Leslie at Artpark, on the Niagara Gorge, in New York State. Begins *Irish Cylinders* and *Ulysses Cylinders* with Leslie and Mace.

1976 An automobile accident in England leaves him, after weeks in the hospital and 256 stitches in his face, without sight in his left eye and with permanent damage to his right ankle and foot. After recuperating he returns to Providence to serve as head of the Department of Sculpture and the Program in Glass at RISD.

Henry Geldzahler, curator of contemporary art at the Metropolitan Museum of Art in New York, acquires three *Navajo Blanket Cylinders* for the museum's collection. This is a turning point in Chihuly's career, and a friendship between artist and curator commences.

1977 Inspired by Northwest Coast Indian baskets he sees at the Washington State Historical Society in Tacoma, begins the *Basket* series at Pilchuck over the summer, with Benjamin Moore as his gaffer. Continues his bicoastal teaching assignments, dividing his time between Rhode Island and the Pacific Northwest.

1978 Meets William Morris, a student at Pilchuck Glass School, and the two begin a close, eight-year working relationship. A solo show curated by Michael W. Monroe at the Renwick Gallery, Smithsonian Institution, in Washington, D.C., is another career milestone.

1979 Dislocates his shoulder in a bodysurfing accident and relinquishes the gaffer position for good. William Morris becomes his chief gaffer for the next several years. Chihuly begins to make drawings as a way to communicate his designs.

1980 Resigns his teaching position at RISD. He returns there periodically during the 1980s as artist-in-residence. Begins *Seaform* series at Pilchuck in the summer and later, back in Providence, returns to architectural installations with the creation of windows for the Shaare Emeth Synagogue in St. Louis, Missouri.

1981 Begins *Macchia* series.

1982	First major catalog is published: *Chihuly Glass*, designed by RISD colleague and friend Malcolm Grear.
1983	Returns to the Pacific Northwest after sixteen years on the East Coast. Works at Pilchuck in the fall and winter, further developing the *Macchia* series with William Morris as chief gaffer.
1984	Begins work on the *Soft Cylinder* series, with Flora Mace and Joey Kirkpatrick executing the glass drawings.
1985	Begins working hot glass on a larger scale and creates several site-specific installations.
1986	Begins *Persian* series with Martin Blank as gaffer, assisted by Robbie Miller. With the opening of *Objets de Verre* at the Musée des Arts Décoratifs, Palais du Louvre, in Paris, he becomes one of only four American artists to have had a one-person exhibition at the Louvre.
1987	Establishes his first hotshop in the Van de Kamp Building near Lake Union, Seattle. Begins association with artist Parks Anderson. Marries playwright Sylvia Peto.
1988	Inspired by a private collection of Italian Art Deco glass, Chihuly begins *Venetian* series. Working from Chihuly's drawings, Lino Tagliapietra serves as gaffer.
1989	With Italian glass masters Lino Tagliapietra, Pino Signoretto, and a team of glassblowers at Pilchuck Glass School, begins *Putti* series. Working with Tagliapietra, Chihuly creates *Ikebana* series, inspired by his travels to Japan and exposure to ikebana masters.

1990	Purchases the historic Pocock Building located on Lake Union, realizing his dream of being on the water in Seattle. Renovates the building and names it The Boathouse, for use as a studio, hotshop, and archives. Travels to Japan.
1991	Begins *Niijima Float* series with Richard Royal as gaffer, creating some of the largest pieces of glass ever blown by hand. Completes a number of architectural installations. He and Sylvia Peto divorce.
1992	Begins *Chandelier* series with a hanging sculpture at the Seattle Art Museum. Designs sets for Seattle Opera production of Debussy's *Pelléas et Mélisande*.
1993	Begins *Piccolo Venetian* series with Lino Tagliapietra. Creates *100,000 Pounds of Ice and Neon*, a temporary installation in the Tacoma Dome, Tacoma, Washington.
1994	Creates five installations for Tacoma's Union Station Federal Courthouse. Hilltop Artists in Residence, a glassblowing program for at-risk youths in Tacoma, Washington, is created by friend Kathy Kaperick. Within two years the program partners with Tacoma Public Schools, and Chihuly remains a strong role model and adviser.
1995	*Chihuly Over Venice* begins with a glassblowing session in Nuutajärvi, Finland, and a subsequent blow at the Waterford Crystal factory, Ireland.
1996	*Chihuly Over Venice* continues with a blow in Monterrey, Mexico, and culminates with the installation of fourteen

Chandeliers at various sites in Venice. Creates his first permanent outdoor installation, *Icicle Creek Chandelier*.

1997 Continues and expands series of experimental plastics he calls "Polyvitro." *Chihuly* is designed by Massimo Vignelli and copublished by Harry N. Abrams, Inc., New York, and Portland Press, Seattle. A permanent installation of Chihuly's work opens at the Hakone Glass Forest, Ukai Museum, in Hakone, Japan.

1998 Chihuly is invited to Sydney, Australia, with his team to participate in the Sydney Arts Festival. A son, Jackson Viola Chihuly, is born February 12 to Dale Chihuly and Leslie Jackson. Creates architectural installations for Benaroya Hall, Seattle; Bellagio, Las Vegas; and Atlantis, the Bahamas.

1999 Begins *Jerusalem Cylinder* series with gaffer James Mongrain in concert with Flora Mace and Joey Kirkpatrick. Mounts his most challenging exhibition: *Chihuly in the Light of Jerusalem 2000*, at the Tower of David Museum of the History of Jerusalem. Outside the museum he creates a sixty-foot wall from twenty-four massive blocks of ice shipped from Alaska.

2000 Creates *La Tour de Lumière* sculpture as part of the exhibition *Contemporary American Sculpture* in Monte Carlo. Marlborough Gallery represents Chihuly. More than a million visitors enter the Tower of David Museum to see *Chihuly in the Light of Jerusalem 2000*, breaking the world attendance record for a temporary exhibition during 1999–2000.

2001 *Chihuly at the V&A* opens at the Victoria and Albert

Museum in London. Exhibits at Marlborough Gallery, New York and London. Groups a series of *Chandeliers* for the first time to create an installation for the Mayo Clinic in Rochester, Minnesota. Artist Italo Scanga dies, friend and mentor for over three decades. Presents his first major glasshouse exhibition, *Chihuly in the Park: A Garden of Glass*, at the Garfield Park Conservatory, Chicago.

2002 Creates installations for the Salt Lake 2002 Olympic Winter Games. The *Chihuly Bridge of Glass*, conceived by Chihuly and designed in collaboration with Arthur Andersson of Andersson·Wise Architects, is dedicated in Tacoma, Washington.

2003 Begins the *Fiori* series with gaffer Joey DeCamp for the opening exhibition at the Tacoma Art Museum's new building. TAM designs a permanent installation for its collection of his works. *Chihuly at the Conservatory* opens at the Franklin Park Conservatory, Columbus, Ohio.

2004 Creates new forms in his *Fiori* series for an exhibition at Marlborough Gallery, New York. The Orlando Museum of Art and the Museum of Fine Arts, St. Petersburg, Florida, become the first museums to collaborate and present simultaneous major exhibitions of his work. Presents a glasshouse exhibition at Atlanta Botanical Garden.

2005 Marries Leslie Jackson. Mounts a major garden exhibition at the Royal Botanic Gardens, Kew, outside London. Shows at Marlborough Monaco and Marlborough London. Exhibits at the Fairchild Tropical Botanic Garden, Coral Gables, Florida.

2006	Mother, Viola, dies at the age of ninety-eight in Tacoma, Washington. Begins *Black* series with a *Cylinder* blow. Presents glasshouse exhibitions at the Missouri Botanical Garden and the New York Botanical Garden. *Chihuly in Tacoma*—hotshop sessions at the Museum of Glass—reunites Chihuly and glassblowers from important periods in his artistic development. The film *Chihuly in the Hotshop* documents this event.
2007	Exhibits at the Phipps Conservatory and Botanical Gardens, Pittsburgh. Creates stage sets for the Seattle Symphony's production of Béla Bartók's opera *Bluebeard's Castle*.
2008	Presents his most ambitious exhibition to date at the de Young Museum, San Francisco. Returns to his alma mater with an exhibition at the RISD Museum of Art. Exhibits at the Desert Botanical Garden in Phoenix.
2009	Begins *Silvered* series. Participates in the 53rd Venice Biennale. Mounts a garden exhibition at the Franklin Park Conservatory, Columbus, Ohio.

COLOPHON

This first printing of **CHIHULY PUTTI** is limited to 7,500 casebound copies. © 2009 Portland Press. All rights reserved. DVD is for private home viewing only.

Photography
Philip Amdal, Theresa Batty, Eduardo Calderon, Shaun Chappell, Jan Cook, Claire Garoutte, Nick Gunderson, Russell Johnson, Robin Kimmerling, Peter Kuhnlein, Scott M. Leen, Teresa Nouri Rishel, Terry Rishel, Mike Seidl, Chuck Taylor, Patsy Wooten

Designers
Janná Giles & Ann Enomoto

DVD Director
Peter West

Typeface
Frutiger

Printed and bound in China by Hing Yip Printing Co., Ltd.

⊺ Portland Press
Post Office Box 70856
Seattle, Washington 98127
800 574 7272
www.portlandpress.net
ISBN: 978-1-57684-173-0

Front cover:
Putto in Nest Kissing
Opalescent Hummingbird
on Orange Vessel (detail)
1999, 31 x 18 x 18"

Pages 16–17:
Putti with Flowers
on Muted Blue
Base (detail)
2002, 26 x 24 x 21"